Latin:
Lumen Ad Viam.

To
Light,
is our
dedication:
three lit candles,
three Books of L

Credit goes to
the team of designers,
photographers, cartoonists,
and editor Dr. Common Sense
at the publisher: D'Moon

Copyright ©D'Moon
second edition, first paperback print: 2019
first hardcover print: 2018
ebook edition: 2014
all rights reserved except for quotes, mottos and poems

ISBN: 978-1-933187-92-1

Slight variations may occur
as part of the print-on-demand process
since each book is manufactured in its entirety.

Your feedback is most welcome ~
publisher@worldculturepictorial.com

BOOK OF L

Quotable Wit & Wisdom

Dr. Common Sense
dmoon books

Publisher's Note

Legacy of the old Latin Fiat Lux
"Let there be Light", like lightning,
inspiring minds from ancient Rome
to digital age, lighting up lakes,
leaves, illuminating hues of
landscape, at this very moment
sheds light onto this Book of L.

"L", a magic ring, holds key words about
Life which is like a line, drawn by
looking deep, listening and learning, by
laboring brain and limbs, and by
leisure; dotted by being lost to fame or
luxury, lured by lust,
laden with desire for lots of lots. Or,
Life can also simply tune in to
lovely music, light footsteps and
laughter, cheery or without choice.

Book of L sees
L in Quotation,
L in Latin Motto, and
L in Poem. Poetry lives beyond
literature, and poets are beyond masters of
languages. Their passion and expression,
brilliance and down-to-earth
cutting wit spark lightning,
lighting up centuries' space time and the way
for generations after generations! Reading
lines from classic poems, heritage to all, is
indeed amusing.

Latin: "Lumen Ad Viam".
Buddha: "Thousands of candles can be
lit from a single candle, and the
life of the candle will not be shortened.
Happiness never decreases by being shared."

Therefore, to Light, is our dedication
~ three lit candles, three Books of L.
Enjoy, dear readers.

Dr. Common Sense

Contents

Dedication
Copyright
Title Page
Publisher's Note
Table of Contents

Section 1 : L in Quotation

Love
- Love lives beyond the tomb

Limit
- no limit to dimensions

Listen
- two ears, listen twice

Loquacious
- strike dumb the loquacious

Love
- love to expect

Book of L - Quotable Wit and Wisdom

Contents

Lend
- lend an umbrella in fair weather

Lar
- Wisdom ond Lar

Lordship
- from his Lordship I shall learn

Little
- little thing, big difference

Languid
- secession of languid Muse

Laugh
- too afraid to laugh

Long
- win in the long run

Leaf
- a leaf of grass is no less

Lead
- small amounts of philosophy lead to...

Dr. Common Sense

Contents

Lead
- to serve, to lead

Link
- link between Man and Nature

Long
- long play the heart's role

Left
- left our bosoms bleeding

Logic
- logic, laws, Nature has her own

Long
- long I stood there, wondering

Luck
- luck: early bird vs. early worm

Life
- life in long-shot

Book of L - Quotable Wit and Wisdom
Contents

Lost
- lost: to be everywhere, to be nowhere
Look
- look farther backward and forward
Let
- let's teach ourselves...
Liege
- dear my liege, mine honour let me try
Line
- a line, a dot on a walk
Light
- little and little, into a full and clear light
Long
- three things cannot be long hidden
Little
- an echo for a little while

Dr. Common Sense

Contents

Lion
- lions led by a sheep

Library
- in libraries grows the book-worm instead of Man Thinking

Language
- language vs. soul

Liberty
- light to eyes, air to lungs, love to heart, liberty to soul

Law
- moral law within

Liar
- book that makes truth into a liar

Lip
- with your life or with your lips?

Language
- good music, primitive language

Book of L - Quotable Wit and Wisdom

Contents

Long
- miss me as long as I miss him
Life
- life would be happier if...
Looks
- falsehood in his looks
Love
- good marriage resembles friendship rather than love

Section 2 : L in Latin Motto

Lux
- Lux Mentis, Lux Orbis
Lux
- Lux esto
Lumen
- Lumen Ad Viam

Dr. Common Sense

Contents

Lex
- Lex Paciferat

Libertas
- Libertas per Sapientiam

Lux
- Lux et Veritas Floreant

Labore
- Ingenio et Labore

Lucem
- Ad Lucem

Lumine
- In lumine Tuo videbimus lumen

Lux
- Veritas Humanitatis Lux

Liberabit
- Veritas liberabit vos

Limine
- In limine sapientiae

Book of L - Quotable Wit and Wisdom

Contents

Lumen
- Verbum Vitae et Lumen Scientiae

Luceo
- Luceo non uro

Lux
- Lux et Veritas

Lucet
- Sol Lucet Omnibus

Labore
- Labore omnia florent

Libertas
- Lux Libertas

Lux
- Lux et Spes

Lux
- Fiat Lux

Dr. Common Sense

Contents

Section 3 : L in Poem

Legendary

Are you Content?
by William Butler Yeats
"half legendary men"

Lament, Lonely, Lowly

A Lament
by John Greenleaf Whittier
"lonely and lowly now
light of her glances
pride of her brow"

Book of L - Quotable Wit and Wisdom

Contents

Lass, Listen, Long

The Solitary Reaper
by William Wordsworth
"Yon solitary Highland Lass!...
O listen!...
The music in my heart I bore,
Long after it was heard no more"

Land, Little, Lily

The Land Of Dreams
by William Blake
"Awake, awake, my little Boy!...
O, what land is the Land of Dreams?...
O father! I saw my mother there,
Among the lilies by waters fair"

Dr. Common Sense
Contents

Lecture, Love

A Lecture Upon The Shadow
by John Donne
"Stand still, and I will read to thee
A lecture, love, in love's philosophy"

Luxuriance, Last, Leaf

A Boundless Moment
by Robert Frost
"Such white luxuriance of May for ours...
A young beech clinging to its last year's leaves"

Book of L - Quotable Wit and Wisdom

Contents

Lad, Lightning

Fidele
by William Shakespeare
"Golden lads and girls all must,
as chimney-sweepers, come to dust...
Fear no more the lightning-flash,
fear not slander, censure rash"

Loon, Lull, Lay, Laughter

The Loons
by Archibald Lampman
"Lulled by his presence like a dream, ye lay
floating at rest; but that was long of yore...
With weird entreaties, and in agony,
with awful laughter pierce the lonely night"

Dr. Common Sense
Contents

Lady

And Wilt Thou Weep When I Am Low?
by Lord Byron
"And wilt thou weep when I am low?
Sweet lady! speak those words again:
yet if they grieve thee, say not so--"

Lustre

The Pilot That Weath'd The Storm
by George Canning
"When he sinks into twilight,
with fondness we gaze,
And mark the mild lustre
that gilds his decline."

Book of L - Quotable Wit and Wisdom

Contents

❄❄❄

WcP Blog | World Culture Pictorial®
Other Books of L

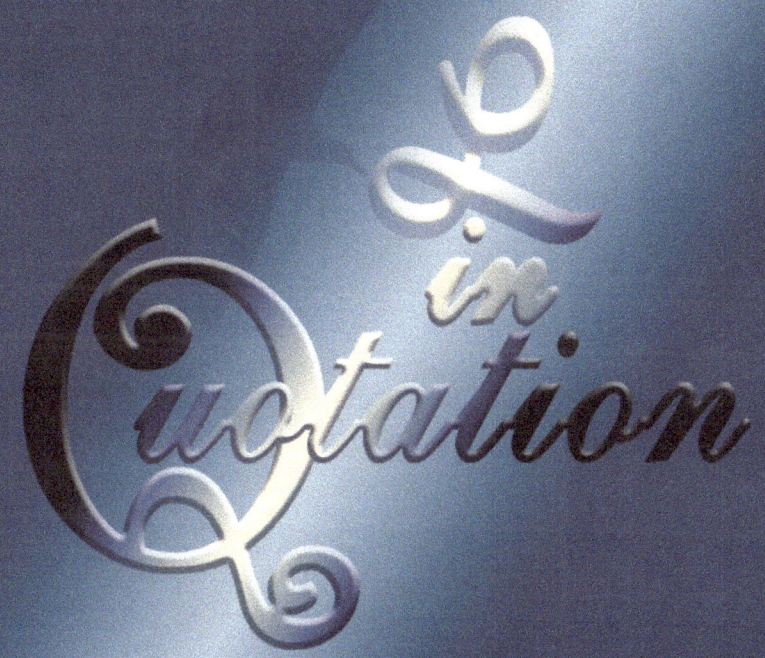

Dr. Common Sense

~ *Love Lives beyond the tomb* ~

"Love lives beyond
The tomb, the earth, which fades like dew-
I love the fond,
The faithful, and the true."
- John Clare

Book of L - Quotable Wit and Wisdom

~ no Limit to dimensions ~

"The wise man looks into space
and does not regard the small as too little,
nor the great as too much;
for he knows that
there is no limit to dimensions."
- Lao Tzu

Dr. Common Sense

~ two ears, Listen twice ~

"We have two ears and one mouth
so that we can listen twice
as much as we speak."
- Epictetus

Book of L - Quotable Wit and Wisdom

~ *strike dumb*
the *Loquacious* ~

"He who seldom speaks,
and with one calm well-timed word
can strike dumb the loquacious,
is a genius or a hero."
- Johann Kaspar Lavater

Dr. Common Sense

~ Love to expect ~

"We love to expect, and
when expectation is
either disappointed or gratified,
we want to be again expecting."
- Samuel Johnson

~ Lend an umbrella in fair weather ~

"A bank is a place where they lend you an umbrella in fair weather and ask for it back when it begins to rain."
- Robert Frost

Dr. Common Sense

~ Wisdom ond Lar ~

"Wisdom ond Lar"
(Old English: wisdom and knowledge)
– motto, University of Winchester

Book of L - Quotable Wit and Wisdom

~ from his Lordship I shall Learn ~

"Then from his Lordship I shall learn...
Nae honest, worthy man need care
To meet with noble youthful Daer,
For he but meets a brother."
- Robert Burns

Dr. Common Sense

~ Little thing, big difference ~

"Attitude is a little thing that makes a big difference."
- Winston Churchill

Book of L - Quotable Wit and Wisdom

~ secession of Languid Muse ~

"Think then, will pleaded indolence excuse
The tame secession of thy languid Muse?"
- George Canning

Dr. Common Sense

~ too afraid to Laugh? ~

"God is a comedian, playing to an audience too afraid to laugh."
- Voltaire

Book of L - Quotable Wit and Wisdom

~ *win in the Long run* ~

"As an occupation in declining years, I declare I think saving is useful, amusing and not unbecoming. It must be a perpetual amusement. It is a game that can be played by day, by night, at home and abroad, and at which you must win in the long run... What an interest it imparts to life!"
- William Makepeace Thackeray

Dr. Common Sense

~ a Leaf of grass is
no Less ~

"I believe a leaf of grass is
no less than
the journey-work of the stars."
- Walt Whitman

Book of L - Quotable Wit and Wisdom

~ small amounts of philosophy Lead to... ~

"Small amounts of philosophy
lead to atheism,
but larger amounts
bring us back to God."
- Francis Bacon

Dr. Common Sense

~ to serve, to Lead ~

"To Serve, To Lead, To Teach"
- motto, Touro University

Book of L - Quotable Wit and Wisdom

~ *Link between Man and Nature* ~

"One of the first conditions of
happiness is that
the link between Man and Nature
shall not be broken."
- Leo Tolstoy

Dr. Common Sense

~ *Long play the heart's role* ~

"The mind cannot long play the heart's role."
- François de la Rochefoucauld

Book of L - Quotable Wit and Wisdom

~ *Left our bosoms bleeding* ~

"It may be strange -
yet who would change
Time's course to slower speeding,
When one by one our friends have gone,
And left our bosoms bleeding?"
- Thomas Campbell

Dr. Common Sense

Logic, Laws, Nature has her own ~

"Nature is the source of
all true knowledge.
She has her own logic, her own laws,
she has no effect without cause
nor invention without necessity."
- Leonardo da Vinci

Book of L - Quotable Wit and Wisdom

~ Long I stood there, wondering ~

"Deep into that darkness peering,
long I stood there, wondering, fearing,
doubting, dreaming dreams
no mortal ever dared to dream before."
- Edgar Allan Poe

Dr. Common Sense

~ *Luck: early bird vs. early worm* ~

"I think we consider too much
the good luck of the early bird
and not enough
the bad luck of the early worm."
- Franklin D. Roosevelt

Book of L - Quotable Wit and Wisdom

~ *Life in Long-shot* ~

"Life is a tragedy when seen in close-up,
but a comedy in long-shot."
- Charlie Chaplin

Dr. Common Sense

~ *Lost: to be everywhere, to be nowhere* ~

"The soul which has
no fixed purpose in life is lost;
to be everywhere,
is to be nowhere."
- Michel de Montaigne

Book of L - Quotable Wit and Wisdom

~ *Look farther backward and forward* ~

"The farther backward you can look,
the farther forward
you are likely to see."
- Winston Churchill

Dr. Common Sense

~ Let's teach ourselves... ~

"Let's teach ourselves
that honourable stop,
Not to outsport discretion."
- William Shakespeare

Book of L - Quotable Wit and Wisdom

*~ dear my Liege,
mine honour Let me try ~*

"Mine honour is my life; both grow in one;
Take honour from me, and my life is done:
Then, dear my liege, mine honour let me try;
In that I live and for that will I die."
- William Shakespeare

Dr. Common Sense

~ a Line, a dot on a walk ~

"A line is a dot that went for a walk."
- Paul Klee

Book of L - Quotable Wit and Wisdom

~ *Little and Little,*
into a full and clear Light ~

"I keep the subject of my inquiry
constantly before me,
and wait till the first dawning
opens gradually,
by little and little,
into a full and clear light."
- Sir Isaac Newton

Dr. Common Sense

*~ three things cannot be
Long hidden ~*

"Three things cannot be long hidden:
the sun, the moon, and the truth."
- Buddha

an echo for a little while ~

"I don't like to talk much with people
who always agree with me.
It is amusing to coquette
with an echo for a little while,
but one soon tires of it."
- Thomas Carlyle

Dr. Common Sense

~ Lions Led by a sheep ~

"I am not afraid of an army of
lions led by a sheep;
I am afraid of an army of
sheep led by a lion."
- Alexander the Great

Book of L - Quotable Wit and Wisdom

~ in Libraries grows the book-worm instead of Man Thinking ~

"Meek young men grow up in libraries, believing it their duty to accept the views which Cicero, which Locke, which Bacon, have given, forgetful that Cicero, Locke, and Bacon were only young men in libraries, when they wrote these books. Hence, instead of Man Thinking, we have the book-worm."
- Ralph Waldo Emerson

Dr. Common Sense

~ *Language vs. soul* ~

"Do not be troubled for a language,
cultivate your soul and
she will show herself."
- Eugene Delacroix

Light to eyes, air to Lungs, Love to heart, Liberty to soul ~

"What light is to the eyes –
what air is to the lungs –
what love is to the heart,
liberty is to the soul of man."
- Robert Green Ingersoll

Dr. Common Sense

~ *moral Law within* ~

"Two things awe me most,
the starry sky above me and
the moral law within me."
- Immanuel Kant

~ book that makes truth into a Liar ~

"It is no great art to say something briefly when, like Tacitus, one has something to say; when one has nothing to say, however, and none the less writes a whole book and makes truth into a liar
- that I call an achievement."
- Georg C. Lichtenberg

Dr. Common Sense

~ *with your Life or with your Lips?* ~

"You can preach a better sermon with your life than with your lips."
- Oliver Goldsmith

Book of L - Quotable Wit and Wisdom

~ good music, primitive Language ~

"Good music is very close to primitive language."
- Denis Diderot

Dr. Common Sense

~ *miss me as Long as I miss him* ~

"I want my friend to miss me as long as I miss him."
- Saint Thomas Aquinas

Book of L - Quotable Wit and Wisdom

~ *Life would be happier if...* ~

"Life would be infinitely happier
if we could only be born
at the age of eighty
and gradually approach eighteen."
- Mark Twain

Dr. Common Sense

~ *falsehood in his Looks* ~

"THAT there is a falsehood in his looks,
I must and will deny:
They tell their Master is a knave,
And sure they do not lie."
- Robert Burns

~ good marriage resembles friendship rather than Love ~

"If there is such a thing as
a good marriage, it is because
it resembles friendship
rather than love."
- Michel de Montaigne

Dr. Common Sense

~ *Lux* ~

"*L*ux Mentis, Lux Orbis"
"Light of the Mind, Light of the World"
- motto, Sonoma State University

Book of L - Quotable Wit and Wisdom

~ *Lux* ~

"*Lux* esto"
"Be Light"
- motto, Kalamazoo College

Dr. Common Sense

~ *Lumen* ~

"Lumen Ad Viam"
"Light the way"
– motto, State University of Ceará

Book of L - Quotable Wit and Wisdom

~ *Lex* ~

"*Lex* Paciferat"
"The law shall bring peace"
- motto, European Gendarmerie Force

Dr. Common Sense

~ *Libertas* ~

"*Libertas per Sapientiam*"
"Through Wisdom, Liberty"
- motto, University of Lincoln

Book of L - Quotable Wit and Wisdom

~ *Lux* ~

"*Lux* et Veritas Floreant"
"Let Light and Truth Flourish"
- motto, University of Winnipeg

Dr. Common Sense

~ *Labore* ~

"*Ingenio et Labore*"
"By natural ability and hard work"
- motto, University of Auckland

Book of L - Quotable Wit and Wisdom

~ Lucem ~

"Ad Lucem"
"Towards the Light"
- motto, University of Lisbon

Dr. Common Sense

~ *Lumine* ~

"In lumine Tuo videbimus lumen"
"In Thy light shall we see light"
- motto, Columbia University

Book of L - Quotable Wit and Wisdom

~ *Lux* ~

"Veritas Humanitatis Lux"
"Truth is the light of mankind"
- motto, Metropolitan University of Educational Sciences

Dr. Common Sense

~ *Liberabit* ~

"*Veritas liberabit vos*"
"The truth shall set you free"
- motto, Canterbury Christ Church University

Book of L - Quotable Wit and Wisdom

~ *Limine* ~

"*In limine sapientiae*"
"On the threshold of wisdom"
- motto, The University of York

Dr. Common Sense

~ *Lumen* ~

"Verbum Vitae et Lumen Scientiae"
"Word of life and the light of knowledge"
– motto, University of Richmond

Book of L - Quotable Wit and Wisdom

~ *Luceo* ~

"*Luceo non uro*"
"I shine, not burn"
- motto, The Highland Scots Clan Mackenzie

Dr. Common Sense

~ *Lux* ~

"*Lux* et Veritas"
"Light and Truth"
- motto, Indiana University

Book of L - Quotable Wit and Wisdom

~ *Lucet* ~

"Sol Lucet Omnibus"
"The sun shines over everyone"
- motto, Lusiada University

Dr. Common Sense

~ *Labore* ~

"*Labore omnia florent*"
"By labour everything prospers"
– motto, Huntingdonshire

Book of L - Quotable Wit and Wisdom

~ *Libertas* ~

"*Lux* Libertas"
"Light, Liberty"
- motto, University of North Carolina at Chapel Hill

Dr. Common Sense

~ *Lux* ~

"*Lux et Spes*"
"Light and Hope"
- motto, Stonehill College

Book of L - Quotable Wit and Wisdom

~ *Lux* ~

"Fiat Lux"
"Let there be light"
- motto, University of Lethbridge

Dr. Common Sense

half legendary men
Are You Content?
William Butler Yeats

I call on those that call me son,
Grandson, or great-grandson,
On uncles, aunts, great-uncles or great-aunts,
To judge what I have done.
Have I, that put it into words,
Spoilt what old loins have sent?
Eyes spiritualised by death can judge,
I cannot, but I am not content.
He that in Sligo at Drumcliff
Set up the old stone Cross,
That red-headed rector in County Down,
A good man on a horse,

Book of L - Quotable Wit and Wisdom

Sandymount Corbets, that notable man
Old William pollexfen,
The smuggler Middleton, Butlers far back,
Half legendary men.
Infirm and aged I might stay
In some good company,
I who have always hated work,
Smiling at the sea,
Or demonstrate in my own life
What Robert Browning meant
By an old hunter talking with Gods;
But I am not content.

Dr. Common Sense

lonely and lowly now
light of her glances
pride of her brow

A Lament

John Greenleaf Whittier

The circle is broken, one seat is forsaken,
One bud from the tree of our friendship is shaken;
One heart from among us no longer shall thrill
With joy in our gladness, or grief in our ill.

Weep! lonely and lowly are slumbering now
The light of her glances, the pride of her brow;
Weep! sadly and long shall we listen in vain
To hear the soft tones of her welcome again.

Book of L - Quotable Wit and Wisdom

Give our tears to the dead!
> For humanity's claim
From its silence and darkness is ever the same;
The hope of that world whose existence is bliss
May not stifle the tears of the mourners of this.

For, oh! if one glance the freed spirit can throw
On the scene of its troubled probation below,
Than the pride of the marble,
> the pomp of the dead,
To that glance will be dearer
> the tears which we shed.

Oh, who can forget the mild light of her smile,
Over lips moved with music and
> feeling the while,
The eye's deep enchantment, dark,
> dream-like, and clear,
In the glow of its gladness, the shade of its tear.

Dr. Common Sense

And the charm of her features,
 while over the whole
Played the hues of the heart and
 the sunshine of soul;
And the tones of her voice,
 like the music which seems
Murmured low in our ears
 by the Angel of dreams!

But holier and dearer our memories hold
Those treasures of feeling,
 more precious than gold,
The love and the kindness and pity which gave
Fresh flowers for the bridal,
 green wreaths for the grave!

The heart ever open to Charity's claim,
Unmoved from its purpose
 by censure and blame,

Book of L - Quotable Wit and Wisdom

While vainly alike on her eye and her ear
Fell the scorn of the heartless,
 the jesting and jeer.

How true to our hearts was
 that beautiful sleeper
With smiles for the joyful,
 with tears for the weeper,
Yet, evermore prompt,
 whether mournful or gay,
With warnings in love to the passing astray.

For, though spotless herself,
 she could sorrow for them
Who sullied with evil the spirit's pure gem;
And a sigh or a tear could the erring reprove,
And the sting of reproof was
 still tempered by love.

Dr. Common Sense

As a cloud of the sunset,
 slow melting in heaven,
As a star that is lost when
 the daylight is given,
As a glad dream of slumber,
 which wakens in bliss,
She hath passed to the world of
 the holy from this.

Book of L - Quotable Wit and Wisdom

>Yon solitary Highland Lass!...
>O listen!...
>The music in my heart I bore,
>Long after it was heard no more

The Solitary Reaper
William Wordsworth

Behold her, single in the field,
Yon solitary Highland Lass!
Reaping and singing by herself;
Stop here, or gently pass!
Alone she cuts and binds the grain,
And sings a melancholy strain;
O listen! for the Vale profound
Is overflowing with the sound.

Dr. Common Sense

No Nightingale did ever chaunt
More welcome notes to weary bands
Of travellers in some shady haunt,
Among Arabian sands:
A voice so thrilling ne'er was heard
In spring-time from the Cuckoo-bird,
Breaking the silence of the seas
Among the farthest Hebrides.

Will no one tell me what she sings?--
Perhaps the plaintive numbers flow
For old, unhappy, far-off things,
And battles long ago:
Or is it some more humble lay,
Familiar matter of to-day?
Some natural sorrow, loss, or pain,
That has been, and may be again?

Book of L - Quotable Wit and Wisdom

Whate'er the theme, the Maiden sang
As if her song could have no ending;
I saw her singing at her work,
And o'er the sickle bending;--
I listened, motionless and still;
And, as I mounted up the hill,
The music in my heart I bore,
Long after it was heard no more.

Dr. Common Sense

> Awake, awake, my little Boy!...
> O, what land is the Land of Dreams?...
> O father! I saw my mother there,
> Among the lilies by waters fair

The Land Of Dreams
William Blake

Awake, awake, my little Boy!
Thou wast thy mother's only joy;
Why dost thou weep in thy gentle sleep?
Awake! thy father does thee keep.

'O, what land is the Land of Dreams?
What are its mountains,
 and what are its streams?
O father! I saw my mother there,
Among the lilies by waters fair.

Book of L - Quotable Wit and Wisdom

'Among the lambs, clothed in white,
She walk'd with her Thomas in sweet delight.
I wept for joy, like a dove I mourn;
O! when shall I again return?'

Dear child, I also by pleasant streams
Have wander'd all night
 in the Land of Dreams;
But tho' calm and warm the waters wide,
I could not get to the other side.

'Father, O father! what do we here,
In this land of unbelief and fear?
The Land of Dreams is better far
Above the light of the morning star.'

Dr. Common Sense

> Stand still, and I will read to thee
> A lecture, love, in love's philosophy

A Lecture Upon The Shadow
John Donne

Stand still, and I will read to thee
A lecture, love, in love's philosophy.
These three hours that we have spent,
Walking here, two shadows went
Along with us, which we ourselves produc'd.
But, now the sun is just above our head,
We do those shadows tread,
And to brave clearness all things are reduc'd.
So whilst our infant loves did grow,
Disguises did, and shadows, flow
From us, and our cares; but now 'tis not so.
That love has not attain'd the high'st degree,
Which is still diligent lest others see.

Book of L - Quotable Wit and Wisdom

Except our loves at this noon stay,
We shall new shadows make the other way.
As the first were made to blind
Others, these which come behind
Will work upon ourselves, and blind our eyes.
If our loves faint, and westwardly decline,
To me thou, falsely, thine,
And I to thee mine actions shall disguise.
The morning shadows wear away,
But these grow longer all the day;
But oh, love's day is short, if love decay.
Love is a growing, or full constant light,
And his first minute, after noon, is night.

Dr. Common Sense

Such white luxuriance of May for ours...
A young beech clinging to its last year's leaves

A Boundless Moment
Robert Frost

He halted in the wind, and - what was that
Far in the maples, pale, but not a ghost?
He stood there bringing March
 against his thought,
And yet too ready to believe the most.

'Oh, that's the Paradise-in-bloom,' I said;
And truly it was fair enough for flowers
had we but in us to assume in march
Such white luxuriance of May for ours.

Book of L - Quotable Wit and Wisdom

We stood a moment so in a strange world,
Myself as one his own pretense deceives;
And then I said the truth (and we moved on).
A young beech clinging to its last year's leaves.

Dr. Common Sense

Golden lads and girls all must,
as chimney-sweepers, come to dust...
Fear no more the lightning-flash,
fear not slander, censure rash

Fidele
William Shakespeare

Fear no more the heat o' the sun,
Nor the furious winter's rages;
Thou thy worldly task hast done,
Home art gone, and ta'en thy wages:
Golden lads and girls all must,
As chimney-sweepers, come to dust.

Fear no more the frown o' the great,
Thou art past the tyrant's stroke;
Care no more to clothe and eat;
To thee the reed is as the oak:
The sceptre, learning, physic, must
All follow this, and come to dust.

Book of L - Quotable Wit and Wisdom

Fear no more the lightning-flash,
Nor the all-dreaded thunder-stone;
Fear not slander, censure rash;
Thou hast finish'd joy and moan:
All lovers young, all lovers must
Consign to thee, and come to dust.

No exorciser harm thee!
Nor no witchcraft charm thee!
Ghost unlaid forbear thee!
Nothing ill come near thee!
Quiet consummation have;
And renownèd be thy grave!

Dr. Common Sense

Lulled by his presence like a dream, ye lay
Floating at rest; but that was long of yore...
With weird entreaties, and in agony
With awful laughter pierce the lonely night

The Loons
Archibald Lampman

Once ye were happy, once by many a shore,
Wherever Glooscap's gentle feet might stray,
Lulled by his presence like a dream, ye lay
Floating at rest; but that was long of yore.
He was too good for earthly men; he bore
Their bitter deeds for many a patient day,
And then at last he took his unseen way.
He was your friend, and ye might rest no more:

Book of L - Quotable Wit and Wisdom

And now, though many hundred altering years
Have passed, among the desolate northern meres
Still must ye search and wander querulously,
Crying for Glooscap, still bemoan the light
With weird entreaties, and in agony
With awful laughter pierce the lonely night.

Dr. Common Sense

When he sinks into twilight,
with fondness we gaze,
And mark the mild lustre
that gilds his decline.

The Pilot That Weath'd The Storm
George Conning

If hush'd the loud whirlwind
 that ruffled the deep,
The sky, if no longer
 dark tempests deform;
When our perils are past,
 shall our gratitude sleep?
No!--Here's to the Pilot
 who weather'd the storm!

Book of L - Quotable Wit and Wisdom

At the foot-stool of Power let flattery fawn,
Let Faction her idols extol to the skies;
To virtue in humble resentment withdrawn,
Unblam'd may the merits of gratitude rise.

And shall not His memory to Britain be dear,
Whose example with envy all nations behold;
A Statesman unbiass'd by int'rest or fear,
By pow'r uncorrupted, untainted by gold?
...

Unheeding, unthankful, we bask in the blaze,
While the beams of the sun
 in full majesty shine;
When he sinks into twilight,
 with fondness we gaze,
And mark the mild lustre that gilds his decline.

Dr. Common Sense

Lo! Pitt, when the course
 of thy greatness is o'er,
Thy talents, thy virtues,
 we fondly recall!
Now justly we prize thee,
 when lost we deplore;
Admir'd in thy zenith,
 but lov'd in thy fall!

O! take, then-- for dangers
 by wisdom repell'd,
For evils, by courage and
 constancy brav'd--
O take! for a throne
 by thy counsels upheld,
The thanks of a people
 thy firmness has sav'd!

Book of L - Quotable Wit and Wisdom

And O! if again
> the rude whirlwind should rise!
The dawning of Peace
> should fresh darkness deform,
The regrets of the good,
> and the fears of the wise,
Shall turn to the Pilot
> that weather'd the storm!

Dr. Common Sense

And wilt thou weep when I am low?
Sweet lady! speak those words again:
Yet if they grieve thee, say not so--

And Wilt Thou Weep When I Am Low?

:Lord Byron

And wilt thou weep when I am low?
Sweet lady! speak those words again:
Yet if they grieve thee, say not so--
I would not give that bosom pain.

My heart is sad, my hopes are gone,
My blood runs coldly through my breast;
And when I perish, thou alone
Wilt sigh above my place of rest.

Book of L - Quotable Wit and Wisdom

And yet, methinks, a gleam of peace
Doth through my cloud of anguish shine:
And for a while my sorrows cease,
To know thy heart hath felt for mine.

Oh lady! bless'd be that tear--
It falls for one who cannot weep;
Such precious drops are doubly dear
To those whose eyes no tear may steep.

Sweet lady! once my heart was warm
With every feeling soft as thine;
But Beauty's self hath ceased to charm
A wretch created to repine.

Dr. Common Sense

Yet wilt thou weep when I am low?
Sweet lady! speak those words again:
Yet if they grieve thee, say not so--
I would not give that bosom pain.

Publisher's Blog:
WcP Blog | World Culture Pictorial
www.worldculturepictorial.com

"This is simply a gorgeous site.
Not only are the photos excellent
but the messages are powerful
and the stories intriguing.
Thank you for such a gem."
- Robin

"...may your blog, ideas and efforts
help many more people."
- Anonymous

"I really like your style
but mostly your initiative.
The world needs more writers
like yourself."
- Steve

Dr. Common Sense

Also Available in Hardcover

hardcover edition: 2018
www.worldculturepictorial.com/book-of-L.html

Book of L - Quotable Wit and Wisdom

Other Books of L

e-edition: 2014
www.worldculturepictorial.com/book-of-L.html

www.ingramcontent.com/pod-product-compliance
Lightning Source LLC
Chambersburg PA
CBHW041313110526
44591CB00022B/2898